I Saw the Glory

Dr. Durussia Jenkins

ISBN 978-1-64468-644-7 (Paperback)
ISBN 978-1-64468-645-4 (Hardcover)
ISBN 978-1-64468-646-1 (Digital)

Covenant Books, Inc.
11661 Hwy 707
Murrells Inlet, SC 29576
www.covenantbooks.com

Contents

Introduction to New Book

THROUGHOUT 45 YEARS OF MINISTRY, God gave me heavenly encounters and visions which have been translated into hundreds of paintings, poetry, and sermons. In this book, I am sharing many of the visions with you, interpreting how they were created, and demonstrating how they can be applied to your personal walk with Christ. I hope you will enjoy the paintings and poetry, which are called *Poetic Gems,* and I pray that the interpretations of these heavenly encounters will bless you and your family.

—Dr. Durussia Jenkins

Through the Door I Saw 1

THE IMAGES OF THOSE PICTURES painted from heaven will be throughout the book. For four weeks, after falling into a deep sleep, what I thought was just a dream became reality. I was transformed from body into spirit form. And I was carried by the angels to places I had never been before on earth or in heaven. I saw the glory of God as I passed by the mountains and hills of God shining with the brilliant colors of gold and silver; it was truly a beautiful place of peace. I saw images of the ages, from the dawning of time throughout the world's history. "Why was it important for me to see this?" My question throughout the journey was "Why me?" Somehow finally I had the answer to my question of "Why?" The people of the world had to be convinced that God the creator is truly real and He is the living and true God of all mankind. I was to convince them through His art that His love, power, and might to create is in all living things and His created power can be embraced in everyone's life. Most importantly, He wants to give us His peace and grace in our everyday lives. The greatest of these gifts is love, and everything in life and the purpose of man, is to be loved by an awesome father. Humbled by this experience I continued to think, "Who was I to be given such a powerful mission to accomplish?" God is the, "I Am that I Am."

I understood in that moment I saw how frail and vulnerable I was without Him. How could I convince skeptics and intellectuals to accept the truth of God's creative power through these images? I realized it was not going to be easy convincing those who would see the images that they were painted by the "Hand of God." I had to

believe what I was seeing myself and then present it to world. My prayer is that people would believe and find hope; whether it makes natural sense or not. Oh, how I love you Lord as I sat in the knowledge of who He is and has always been, I wanted to please Him. This was the most glorious oasis in the entire universe. His love for us is beyond human understanding, and His reasons to forgive us is even more confusing. He then spoke and said, "Man is my deepest desire of pure love." "Wow!" This knowledge was beyond natural or human understanding. The revelation had now been given to me to make it visible for people to see in all the colors as He/God creatively arranged them together in perfect harmony. I was dumbfounded.

> *And I was transported on a journey through time and glimpsed all the centuries of the past that each of us take in our lives watching man and his paths there it was unfolding before my eyes. The revelation of wholeness was helping me conquer all my fears, giving me an awesome glimpse into the city of God eternal. As I was carried by the angels of glory, we burst through misty clouds, moving further in the heavens toward the steps leading into His most holy place. I gleaned the beauty of Him who is everywhere and it, simply took my breath away, I wanted to stay. It was magnificent and spectacular, yet very simple.*

The road was filled with rocks of all kinds, each one with its own design. All around me were luscious colors of purple, red, blue, and golden yellow, and many others that were not of this natural world or had been seen by human eyes. The greatest earthly artist has never beheld colors as these.

The golden brushes lining around the throne are filled with moments of time unfolding our lives divine. God paints our lives with colors of hope and then blows those colors into the atmosphere where we live each and every day. The air we breathe then reveals the picture on our personal canvas. That's why the scripture in Psalm

118 reads that He knows the plans for our lives because it has already been painted in the atmosphere. I guess we can say that each of us fulfills a work of art, a one of a kind original piece. Through the power of God our destiny will be revealed. We are the handiwork of design, His hands are our hands, and His power is available to us for us to create His glory as we live on earth. His hope is for us to enjoy His beauty while separated from Him until we join Him eternally in glory. In God's hand, our hands, that are creating things on Earth it is for us to glean from His glory while we live on earth naturally separated from Him. I saw that it was God creating throughout time. All these beautiful created things for us because He loves us so much while Satan hates all creation and everything that he lost or should I say gave away, because of his own greed and hatred toward God. These beauties are for us to enjoy despite the evils that surround us each and every day. He showed me that we are all created differently just as these wonderful sights that I saw each one uniquely created.

Even if we don't know it exactly, our personalities resemble these natural everyday products that we use for our livelihood like plastics, aluminums, irons, and paper. Through the spirit of God, if we listen, these items will speak to us and show us who we are as we use them. Instantly I witnessed a miracle I saw a picture folding itself into an image. I saw plastic twisting into shapes of all kinds. God has made us like those products, the plastic and paper, shaped perfectly and cut in certain styles. Each life in its inception was like the miracles I be held. Some people's lives are like plastic, while others are like tinfoil. Many are like are paper shaped and cut to fit a certain style. At times we are knotted and twisted and maybe even balled up into a ball, but whatever the shape or size there is a common ground we share and that is God molded us so that we can bring Him pleasure.

His Revelation was revealed to me that being different is a holy gift from God.

Through these differences, God has given us the power to overcome every obstacle in our life. What may look like a defect on earth is glorious in heaven and absolutely perfect. We are perfectly whole with knots without folds, and without evil at all. We cannot allow the world to confuse us with evil lies; convincing us that we are the

strange ones with something wrong with us. We have to overcome all the evil that comes to destroy our faith and hope in Him. I heard Him say, "I created you to be special." You are the mystery of time. Suddenly before my eyes appeared an image of a beautiful plastic lady dancing ever so perfect. The angel who had accompanied me on this journey asked me. "Do you understand?" I nodded my head yes acknowledging that I did understand. I was seeing through revelation I thanked him. He asked me, "Do you understand?" I nodded yes and suddenly I could see even more clearly through revelation that what God creates is always perfect.

We continued to move towards another space, and His hand struck the canvas with one blast of His love. And like a movie playing from beginning to end I saw clearly before my eyes every other human on earth. I quickly passed by and I was tried by time through all the eternal life with Him. I had passed the test of life. I could see perfectly that only with this love and authority I could conquer my personal fears. Then my mind turned to the others before me, what about them? Who can endure? And the voice spoke to me again, "Everyone can, if they will accept the truth!" The color of love is always red. For greater love hath no man but to lay down his life for his friends. (Jn. 15:13 King James version). He meant it all of creation, even though it was also meant just for me. Dancing in the air were colors everywhere. I watched the colors blend by mixing and matching together while hugging the air. It was the epitome of beauty everywhere. If the colors did not blend and touch, then they would arrange in ugly patterns, and that was not what God wanted. Every person had to surrender to the great painter, God. This picture was coming together of the nations into unity making our God glad.

Even more spectacular was the colors blending into a stream as a river of colors flowing from the throne of God. I saw people standing in the stream. They were the stream, floating as one unit quickly toward His majesty. I saw the door open wide for all. He who has given His life for all humanity and to those who seek to find rest eternal. The voice

of hope called out. The salvation banner floated upward and then down; dancing with joy while waiting for everyone to come into it. The motions of time threw out the line of the generations before it, and the presence of faith caught everyone, grabbing it tightly. They were quickly covered by love and whisked away. With power and might, everyone held on with hopeful determination and trust. They wouldn't let go because they knew it was for those and their loved ones. The words materialized in the air, "I knocked, and you heard. Behold, I stand at the door." At that moment, I saw the door. The flame of hope captured every color of the universe. No eyes have ever seen this amazing beauty. It was the door to what cannot be seen with natural eyes. In front of my eyes were candles that did not flicker anymore. It only shined brightly to the book of Revelation. Suddenly, I see myself as a little child reading His word for the first time, lost in time. I saw the divine wholeness in rhyme. It was the heavenly train eternal cords of preparation, transforming each person that parted from earth to the eternal state of waiting forevermore. Each time a person on earth grabbed the banner, I could hear the words, "I repent suddenly they were transported into the glory. Then another person would see them, and they too would reach for it until it became an electrical current, devouring evil powers and saving each person. God's love transformed them from natural to supernatural, wrapping them in His presence.

It was blue fire and red gold, which made the color of yellow fire appear. The minds of all who called out to God became the I am that I am. Everywhere in this space of time was I am that I am. The words that burned throughout the heavens shook the earth beneath. All things future and pres-

ent were confirmed in time, so what had been before time was and is written from the beginning of time until now. Genesis 19:17 (KJV) says, "And it came to pass, when they had brought them forth abroad". He said, "Escape for thy life; look not behind thee, neither stay in all the plain; escape to the mountains of the Lord." Then I saw another scene. In Genesis 19:26, Lot's wife looked back and became a pillar of salt. The banner is still waving and calling out to those waiting for it. I noticed colors forming again by the voice of creation. I knew this painting had a name, The Journey.

Suddenly, the scene changed again. I saw Luke 9:62, "And Jesus said unto him, No man, having put his hand to the plough, and looking back, is fit for the kingdom of God." I covered my mouth and whispered, "Please, God! Let me be fit for your kingdom?" "Come quickly" I heard the voice say. "Now!" and instantly I was there in His presence. The word of God appeared in Luke 13:3. The words were dancing in the heavenlies as crystal clear bubbles. "I tell you, but unless you repent you will all perish" (Lk. 13:3, NKJV). All I could think about was the beauty of the bride. The beautiful Bride of Christ! I will become the "holy bride." I cried out, "Save them, Lord!" And He heard my cry. I could truly understand that the image of the bride was for all nations of the world. The holy bride of Christ would be the honored guest at the royal marriage supper. "When will this be?" I asked, and His reply was, "When all have seen my glory." All who dwell in the halls of justice and might agree. The image became visible on a piece of paper, suddenly I found myself sitting up at the table and the image of the bride was there painted on the canvas. How?

Without warning, I was transported again into a greater realm of glory. There I stood looking at the world.
These words were spoken as this image appeared out of the glory. "Who is the bride?" I asked.

I watched the people waiting patiently to be counted and approved for entry into the open heaven. All of a sudden, God the Father spoke to me upon my arrival. He said, "Will you go with me?" "Yes," I replied. We continued to walk along this breathtaking path that led to a complete understanding of all things pertaining to human life. I felt instant joy and absolute fullness in mind, body, and spirit, but also some remorse. I thought only joy and peace existed in heaven. Before I could ask another question, came to me. I was experiencing what it is to be separated from the pure truth. While in earthly form, one must conquer that struggle to totally believe the truth concerning God. This is why we struggle on earth for the truth over our human emotions. The enemy of our soul uses this one emotion to defeat us, which is raw doubt about God's love for us. The spirit of remorse is the emotion to remember. This is why we are never satisfied or happy with our everyday lives. No matter how successful we are, there is still an empty hole inside our heart that nothing can satisfy so we try to die before our time. For many hope is lost and faith is unfulfilled but there is hope in the King of Kings. God's word is true and they speak, "Prove me," the Lord commands. "See if I want open the windows of heaven and pour out a blessing" that has to do with our entire lives to be successful in everything. It is to be granted access to see into the future and believe that it is real. My heart leaped for joy at that moment. All of heaven rejoiced for me because I did believe. I saw as a little child, the kingdom was for me and all eternity. Still I waited to be educated by the heavenly tree of life. The kingdom of power entered me, and I had entered into it. We were one in total unity. I was following as a child, and willing to follow God, my Father. I was learning to obey. Would it be possible for me to make things better or maybe even change some things that were unfinished? Things I should have done differently while in nat-

ural form. The answer came in the form of pure light beaming across the heavens. Light will destroy darkness in any form. I felt the guilt of humanity; from birth to young adult. I could have changed some decisions.

Again, the voice spoke, "You must not think only of experience here but see what is important. Then, and only then, will you understand what is expected for thee while you occupy a mortal body." A poem believing this is something I had to learn.

> For as a child, I always yearned
> To see the fantasy of my childish dreams.
> I did not know as you grow,
> You would have to believe more and more.
> This is the only way to grow.
> For as you grow, you will hurt more too.
> For this, no one told me, but I found out it was true.
> Growing sometimes makes you blue,
> But I do not sing that song.
> For someone named Christ came along,
> And I gave my heart to him.
> He took, blessed, and filled it up.
> Now there are no empty places in my cup
> I am here to believe all over again.

I heard the words of this first poetic gem in my head and breathed the revelation inside my spirit. The lingering thoughts of yesterday immediately vanished, leaving only the beauty of the moment. No more remembrance of the past, only my forever future was now revealed. All things were burned away in the thoughts of now. I did not want to leave this beautiful and most holy place. My face was covered by gold and silver, glittering throughout the cosmic dust and illuminating with perfect trust in the presence of a Holy God. I suddenly saw my thoughts and emotions appearing in the wall of eternity, even though I did not speak out loud. My inner thoughts wrote into the glory.

Captivated by the awesome music beating as a pumping heart, I realized my mind was in time with each of the beats. The music and I were in complete unity. The music that permeated my heart and mind was truly divine. The harmony coming forth from the golden instruments were playing softly with the glory of God, filling up the fullness of His presence. With the shouts of grace and glory, I could hear without any fear of the sounds that played my destiny. I watched the destiny of the world below my feet. Also from the music, the fragrance of beauty and peace calmed the entire heaven with a powerful glory.

Nothing could shake the foundations of this place of grace and power. All substances were transparent yet solid like rocks, which were the same as the rock that the earthly builders rejected. Christ is the rock that holds everything grounded throughout the centuries with precious care. He stabilizes the earth with His tender patience. Christ is the pure gold of God. He is everywhere you turn, imbued with pure love that shines with refining fire. Gold honors God in humility, and Christ honored His Father. It covers the arches of heaven with pure white liquid that is the hope of eternity. Which is the assurance of God's promises to humanity, it rotates like billions of crystals, reflecting God's glory. I knew that goodness comes from this substance which is love. I wanted everything. Oh, to be as He is, I cried.

It did not take long because I was suddenly covered and filled with it. His awesome beauty flowed through me like a gushing fountain. Above my head, the mist swirled around creating an opening. The clouds parted and blew life (throughout the space of my existence. The water was as crystal clear as a mirror reflecting all my tears. I saw a fountain overflowing over its sides; and spilling over on to the floor. I realized it was my fountain bursting forth for those I would share the word of God too. My entire spirit leaped with exuberance and blissful cheer as my mind calmed with incredible peace at the same time. Heaven was rejoicing with me. My hope for humanity was touching the throne. It was praise and worship and spontaneous pureness flowing from the walls. The heavenly host were shouting with praise. I realized heaven waits to gather before it releases the

ancient praise that shatters the heavenly state. Everything began to sing praises from the deep within. I knew it was the eternal presence of God honoring the invisible creatures and angels together.

So great and fair, the Master of all things arose and hovered over my head. I bowed with humbleness and grace. I was in Him and He was in me. There was a season of pain, but now it was gone forever. Nothing could disturb my rest. The test was finished and my joy was full. Never again would I experience the sting of rejection. I shouted, "I am free!" The voice of God agreed. "Is this me?" I asked. He said, "Yes, it is." The joy I felt was incredible! I saw the tapestry of writing glowing with hope on the wall of compassion, I could suddenly breathe without any effort. There were no pressures or weights on my chest; I just moved up and down, floating freely without the sting of bondage. Every great writer of words and the great poets have borrowed or stolen from God's worded wall to give to the earth. Most of them have not given the honor to God, though their gifts and talents came from Him. His grace is always standing beside the word of hope. I saw His hand stroking the tapestry with words and sayings, and handing them to me. I saw His amazing love reached through the veil of shame and said, "Go! Tell them, that I love them; and show them my love in the beauty of colors. The tapestry is never without words of hope and faith. I honor God, my Father. I love you always. Help me see what is pure and lovely, because that is who you are to me you are the historical tapestry, in it are we made free."

I saw how the pressures of living in a world that is full of disappointments will cause pain in our everyday struggles. For most people living every day is almost too much to bear. I knew I wanted every person to feel this jubilation of freedom I felt in this beautiful place, not worrying about anything but simply assured that I belong to God and confident that He loved me. God let me feel what others were lacking. I cried, folding my hands and bowing my head in humility I had to pray for them. I heard His words, "I have come that you might have life, and have it more abundantly, with joy unspeakable and full of glory." God wants to be the anchor to the soul of man. I shouted out, bursting in jubilation. For the freedom of hope is eternal! I asked the voice of many water, to let me remember for

just a moment why people refuse to accept His gift of love. I sincerely needed to understand the spirit of man. I looked up and saw the mystery, as sad as it was, the words appeared; because the world enjoys pain.

I realized that pain fights against the spirit of compassion, and compassion is what compels us to obey His voice while in earthly form. Jesus was moved by compassion while living on earth. It was the reason for His suffering. He took our suffering and turned it into external, internal, and forever joy that will carry us home. As I looked through time and through the eyes of God. I saw this day in time, and all things were instantly left behind all remembrance of pain. I now understood my mind set. As a human we love pain, even though we say we do not. It gives us a reason to complain to Him and justify why we can't believe in Him. This truth is so crazy yet completely true. We refuse to accept that the choices we make on earth are our own decisions because He gives us free will. Everything else stays the same. It is human nature to blame someone else for our state of affairs. Everything that happens to us is our choice, one way or another. All of my deceptions and perceptions changed. My destiny was in my hands. Every man has the same gift to choose right or wrong.

As I understood this truth, a musical note was played. We are His music in heaven, and everything we do is recorded. Thank God for His glory was revealed. All flesh will see it together. The only way to have any revelation is to cast off worldly thoughts and fears because these emotions will separate us from God and the understanding of His truth. In Philippians 4, verse 6, it reads that whatsoever things that is true, will follow with a love of music that will make you feel good. Then it will be easy to accept a good report, especially when you think on these things. When you think about evil, it is always opposite of the truth that God's word declares. But if you accept His word over the devil lies, you will hear a positive musical note played. If not, you will hear a minor note played. We must live in the positive notes of God. This will cause the atmosphere to change from heavy to light and airy. Therefore, whatever is written from the mouth of God is perfect and complete. The devil is the very ugliness of evil so

only evil will come from him. Satan cannot tell the truth because he is twisted, and coiled up like a snake. The only sound he can emit is hissing.

I was waiting on God to teach me to listen with only the beating of my heart. As He gently held my arm, He asked, "Can you see?" "Yes," I replied. Seconds later a face appeared in the mountain of believers. I heard His calming voice, "Come and see more. Behold my mystery;" I followed His voice ever so sweetly. "I need and want to go with you, Lord." I whispered, "I need to learn." I was on a journey with His presence. Hour after hour, I was transported to the land of wisdom and great revelation. "My daughter," He said, "be not afraid, for nothing can harm you when you are with me." As we inched closer and closer to this most holy place, the many waters inside my belly rumbled uniting with the gentle breeze calmed my spirit. I knew something was changing, instantly I was transformed into glory and ultimately my doubts and fears fell off of me. I was as pure as gold.

Awakening the next day, my natural state was absolutely different. All I wanted to do was go back in time with God. The cloud appeared over my head an invisible hand reached through the cloud, gently took my hand, and began painting on the canvas in front of me. I watched as the Maestro of time painted a beautiful painting of angels waiting in a garden. Oddly after this encounter, I fell asleep and was transported again. How long I was there, I do not know. When I woke up, it was morning, and there were three more paintings. After this night, I had no more fear at all. I praised God for all He had done through me.

Events throughout Time 2

ON DAY 2, I SAW the wall of history, from the beginning of time to my present time. *Why was history so important?* I wondered. What I heard was, "Without it, one will not have any way of finding purpose to continue one's life with joy and determination that will help them endure hardships as a true solider of Jesus Christ." I saw written on the wall throughout time, "Someone had to pay of the price or penalty of death so that others could live." There were names and faces of those who paid the price of giving life to others. George Washington, Abraham Lincoln, union soldiers, and confederate soldiers were written in the wall that never ended because brave people would continue to sign their names in service to someone for eternity.

Only God remained steadfast throughout all of eternity for He is eternity. How could I ever doubt Him about anything on earth? He has the wisdom of creation and the power to create our world, the great and mighty city of God. Oh, how I never wanted to leave this place of glory! Every word spoken from the lips of God has magic to them for they danced around the walls of justice and clapped with joy. Nothing can stand against righteousness. It is the pillars of hope for eternity. The angels wait in the garden, the holy place where all things are fully complete. With sharpness of mind and spirit, they gather together, keeping all things intact. It is a beautiful altar to God.

 - I wanted to write so I asked the angel if I could. He answered, "Yes, look!" He pointed at something, it was my name. "It has already been written before you were born, and now you can write for oth-

ers too." So I began to write…or at least my mind spoke, and the invisible pen in my mouth wrote it. *Poetic Poems and Gems*, The words I heard was creative indeed because I was walking in the dust of glory, my feet was not seen as I moved about the space as I was drawing supernatural power. *Am I a flower?* Suddenly, the warm air blew across my face and a kiss from my beloved, embraced me. Ah, a new twist for my eyes to see!

POETIC GEMS

Thoughts of the father's heart.
I knew then that only the Son could ever know the
Father's heart,
But who knows the will of the Father?
The one who hung who knows the father's grace?
We do who needs to walk in faith? You and me.
Who knows the salvation plan? The sinner man.
Who knows the day or the hour God will send His
Son?
Not even the angels who wait for His return.
All creation will he take back? A holy nation POEM

Sometimes we ask why, as I have done before, not realizing God knows what He is doing. We try to figure it out, instead of letting go and giving it to God so He can do what needs to be done. I have always gotten in the way, searching to work it out, not stopping long enough to talk with Him. He said He'll never leave us, but with every temptation, He'll give us an escape route.

This brings me to a story about a man named Abraham who had a special son. One day, God told him to take his son up a hill. Abraham never struck up a deal, even though he knew his son would die. He was so in touch with the Father so he did not ask questions. It seemed so very strange to me, but His ways are not our ways; so I asked God to let me see the glory of His presence. God supplied a ram in the bush. I'm sure Abraham knew that the Lord didn't want him to ask why; He just wanted Him to obey.

Suddenly I saw this story written in glory. There was a boat drifting in the water, floating on faith. The ocean was wide and incredibly beautiful. The sun was shining, and the clouds seemed to move with beauty as if to give the peace of God's approval of the moment. They were fluffy and billowy; yet beneath the water, a dangerous thing was lurking about waiting to strike. It was the spirit of fear. "I am not afraid of you!" the boat blurted. "You don't scare me. I have strong currents and winds that can destroy you!| the sea yelled back. "Can't you hear my rage?" But the fearless little boat knew something that the sea didn't. Faith was sailing that day also. So the boat said with confidence, "I will conquer you. I am small, but I am determined to sail upon your back. And when I am through, I shall make you my friend." That's a fact because faith is more than an act. It is trust in God, the Creator of us all. Sometimes we need to just set sail and believe by faith that we are secure in following the Lord's lead. The disciples were on the boat with Jesus. While Jesus was asleep inside the boat, a violent storm suddenly arose, and they were afraid. Those boisterous winds made the disciples freeze in terror. The fear took over their emotions, which caused them to faint in their faith. They actually forgot that Jesus was on the boat with them. "Master, we are perishing! Don't you care?" Jesus spoke and said, "Winds and waves, cease!" Everything calmed down instantly, which saved them all and ultimately taught the disciples a lesson, where the spirit of the Lord is, there is peace.

Satan has done a brilliant job in keeping the church filled with fear. Where there is fear, there is torment. When torment is finished with you, your mind is hopelessly confused and broken. Therefore, you are good for nothing. Jesus said in Matthew 8:26, "O ye of little faith?" What the disciples did not know was they had been set up for this test. Jesus was the boat, the storm, and, ultimately, the hope of their tomorrows. "Upon this rock I will build my church; and the gates of hell shall not prevail against it" (Matt. 16:18, KJV). We must believe that Christ is the water that flows from the throne of God. The crown of glory stands above the clouds and make us want to worship. I will worship in this mountain until my last breath for the Lord is my rock and my salvation. No one else will I fear. Fear is

Where there is
fear, there is torment.

The newness of life happens everyday

torment. I refuse to be tormented by the things that I cannot see or taste. By grace, I will hold on to the little that I possess for its all that I have at this present time. May the little I have become the most costly, and may God multiply it into an eternal treasure unmeasured.

There is a time in our life when we have to change from spring to summer then to fall. Spring brings the budding of the flowers and many days of showers. This makes the flower to grow and become beautiful. But as the flowers grow, so must we. From hour to hour and minute to minute, we are changing gradually and rapidly. It is mostly unnoticed until something makes us look into the mirror, then we see the change, and it is always shocking. Sometimes changes aren't noticeable until something or someone dies. We must focus on the newness of life because it happens every day. This is the plan of God for every soul. We must stay steadfast on the future. The summer comes, and there is pressures that weighs us down, and with it comes new challenges. Inevitably, we see that our lives have passed us by. Don't forget to pay attention to the obvious. We missed the most important pivotal moments, circling in confusion and emptiness. When we regain our thoughts, things are unfinished. Now we say, "I am old."

As I walked through the heavenly shield with the voice of God, I realized all seasons remain the same. Even though it appears to change, it really is only us changing. Creation remains under the shadow of the Almighty for there is a season and time for everything under the heaven. Here I was in heaven. I had already been born and transcended into time. How awesome this experience was to me! I know that hope is stable and complete forever. I began to understand that we need to remove things that separate us from God and break down our willingness to obey God and build up His kingdom. The casting away of stones that are of no value in our earthly state is of no value in the heavenly state. Weeping must endure for a night, but joy will always come in the morning light. We have to learn how to mourn, but we also need to learn to dance and worship God through all things. Most of all, we need to cast away stones that hinder us and gather those stones that celebrate our life. It made sense when He says in Romans that He will make all things turn around for your good,

even if it is bad in your earthly state. God will turn it into good for your heavenly state, which is ever present while you live. He showed me the changes in times and seasons. I saw the downfall of kings and the setting up of kings for the time of wisdom had begun. Only through God; the Father could I fully understand humanity and the things present around me. I asked, "Would I...could I become a revelation into my heart?" The answer was yes!

Peace and Prosperity 3

On DAY 3, I THOUGHT of those things that I beheld in heaven the night it was hard to understand them all but I assure I would understand in time. Little did I know, I was becoming the revelation every time I went there. I beheld His glory and saw Him as He was. The next night, I went to sleep and was whisked again to be taught about life, and its tedious everyday routines. We practice and follow evil until our conscience is dull to sinning. We don't even feel anything, and it is really nothing to us. I again heard the voice calling to me to follow, Genesis 8:22 (ESV) says "While the earth remains, seedtime and harvest, cold and heat, summer and winter, day and night, shall not cease." This is your rein or rain the two words are really the same. To rule are those who are found worthy shall rule with Him. To produce God's glory are those who have been granted privilege to release His glory. For those elders knew that they are His gifted gold. He is God his majesty forevermore. There is none besides Him. "The seasons are your friend," He said. "Without hope in me and your faith in my word, all things will suddenly die and grow into gross darkness. This doesn't have to happen if my people know who they are. You must never forget my purpose for you, my will for your life, and my desire of hope for you. You have the power to prevent gross darkness if you stay in the light, breathe in light, sleep in light, and dwell in the light." I Philippians 3:13, it reads to always apprehend the light and to never forget God but reach for God in all that we do while living in our earthly estate and remember He will never leave us. In 2 Chronicles 7:14 (ESV), it says, "If my people who are called

by my name will humble themselves, and pray and seek my face and turn from their wicked ways, then I will hear from heaven and will forgive their sin and heal their land." For the words I saw and heard spelled "Faith."

Adding the words in Hebrews 10:38 (KJV), "Now the just shall live by faith." You can never look behind you or draw pain from your past. God is in you, which means you have only the future to behold, not the past it is all erased. There is no pleasure in the past because He said He is the past, present, and future. That means you are too. You must remember that you are not one of those who lost their souls and drew back unto perdition. I looked at my hands, which were white and pure. You are in the now and changed into the now. What was before is no more. Now that you have repented, the kingdom of heaven is at hand (Matt. 3:2)! The voice continued to speak and reveal that He came to call all the sinners to repentance, not just the righteous, by reversing the sentence of death, hell, and the grave. The dancing began again all over the heavens; even the clouds and those below began to rejoice in my understanding of all knowledge. Luke 15:7 (KJV) declared that joy shall be in the courts of praise in the heaven over one soul returning home. In that instant, I saw a child being carried by His train. There is rejoicing and colorful glory released into the atmosphere. The angels flew up and down with glee and all of the heavenly hosts were united in praise. All of the heavenly host worship in unity and the sound echoes throughout the heavens.

It is God's light shining through us each and every day that keeps it shining throughout the ages. It heats creation, even though it is cold in the winter, and regulates the heat in the summer. Glory is what turns the colors in the fall. I began to understand Love is the opposite of Hate. "Do not let your light go out because you don't immediately understand a thing," He said to me. "Turn the light on within you. I put my lamp inside your soul. When the world goes completely dark and there is no light, my people will shine like a lamp so the world will see it. My people have let their lights grow dim. Some left their lamps and went into the marketplace, seeking for more oil. My oil is inside you, and only your love toward me will

keep it burning brightly forever." I saw the words again on the wall of remembrance.

Revelation 2:21 (KJV) says, "And I gave her space to repent of her fornication; and she repented not." I saw the number 4 and 21. What did those numbers mean? According to Revelation 3:3 (KJV), "Remember therefore how thou hast received and heard, and hold fast, and repent. If therefore thou shalt not watch, I will come on thee as a thief, and thou shalt not know what hour I will come upon thee." "What do you mean?" I asked. "With simple minds, you believe that time is twenty-four hours in a day, but I say, four hours is equal to four centuries for me. You will know not the day or the hours in which I will return, but know that I will indeed for I am that I am in You."

The next night I fell asleep. I saw the door open wide for all willing to seek to know Christ. As I entered, I gazed upon His face, and I saw before my eyes for the future of humanity. Yes, God the Son was waiting patiently for all humanity to join the great gathering; for the last of eternity to come. I felt great jubilation and joy, but also some remorse, because I instantly remembered I could have done more. The lingering thoughts of yesterday immediately vanished away. No more remembrance of the past it was now gone. Only the future was revealed. The foundation of all things was burned away in the thoughts of yesterday. I did not want to leave this place again, but I knew I would. My face was glowing with gold and silver so bright and gloriously throughout the cosmic universe. The holy dust glazed the celestial heavens above. It was an invisible shield; the entire sky which made me believe in God's love all over again. Never had I ever felt such wonderful peace! This time, I heard beautiful voices of all the angels singing joyfully. I joined in and realized my voice was equally matched with the angels becoming one with them. My body was a temple of the Holy Ghost and no longer a natural one I became completely spiritual. The golden instruments that appeared in the air filled the room. It was incredible. There were no more walls of division anywhere, none present. How beautiful it was. All creatures were bowing and kneeling before the "King of all Kings." It was the same rock that the children of Israel saw in the wilderness on

their way to the promise land. The rock Moses struck twice for the water to flow out.

A Light Carried Me and I Saw

I saw the power of love holding all things together and secure. It is the power that grounds us to the spirit of sanity and hope. It is the power that gives us fortitude to stand in the midst of trouble. With mercy and grace, I saw the heavens open above my head. The mist that swirled around blew new breath of life upon me from the opening. All I could do was cry. I shouted, "I love you, Lord! Praise rang out from my most inner being. I saw the writing of hope on the wall of compassion, I breathed without heaviness or weight upon my chest. I saw the picture of a blind man with the withered hand who was brought to Jesus. "Master, who sinned? Mother, or Father?" Jesus answered, "Neither. His condition is for the glory of God." Then He healed him. I understood then that love is always present when God comes.

As I closed my eyes, I woke up in bed. With my heart pounding, I whispered "I will go with you, Lord. May I walk with you?" I was at end of my rope, I didn't quite understand why? I saw the clock of people in the clock of time, there are no lines; or numbers like on earth, because every click was a person moving up or down. It was up to every person as to which way they would go, and time was choices as to whether it went forward or back. I felt there was not any hope, but then I heard, "You are the hope, inside of you is the spirit on the wheel inside the wheel." There it was right in front of me, the image on the canvas. What I eventually will do, will turn the time, which is the ticking clock toward me or away from me. "You also have the power to move the wheel from side to side as well," I heard His voice say. "Will you go?" my answer was, "Yes, I will!"

After two weeks have passed, I was still going in and out of heaven; and having more and more intense encounters with the voice of God. I knew for sure it was real encounters in heaven, I was not afraid. I was excited to see all that God would permit me to see and

taste. I felt the pain of many people who were hurting, broken, and certainly lonely. Compassion filled my heart because I knew God cared for them.

I saw a young girl captured inside of time, but it was against her will. It emerged right in front of me. I saw a young girl, and her suffering was serene. I began speaking as her, and here are her thoughts. "It seemed the more I tried, the more I heard the word no," she said. In my mind, I took a walk and tried to think, but my heart continued to sink deeper and deeper into a hole. I heard a voice speaking out loud. "Where are you going?' It was a strange question because I was not moving at all only in my mind. Then the voice asked me if He could go with me. I was confused. Suddenly, I realized that I had turned my head without the weight of the world sitting on top of it. I had not been able to do that before. I had been set free by this voice that called out to me. Thank you, God! I asked Him if I could go with Him. He answered, "Yes, you may." I asked again, "Can I stay?" "I hoped you'd ask that for this is your glorious deliverance day."

I knew it was time to present the gospel of truth to those poor souls bound on earth, especially the young and innocent ones. "I saw the water that flows from a heavenly well, and everyone that drinks from it gets healed." So, I filled up buckets so I could give that water to all who was thirsty.

In the Valley Vision of Separation

I was sent to the place of war, the fierce battle of time where those who must fight would make a stand. I saw the images that frightened me. I did not understand it at first. It was a place in the atmosphere where people were tormented with their personal fears and doubts. Arrogance and stubbornness brought them to the land of terror. Their lives were forever changed into the spirit of darkness with chains about their necks and shackles on their feet. It is all over now. Never will they look back to wonder for they are lost forever. They now know the truth, and the truth cannot help them ever again.

There was a man named Ezekiel who had a talk with God. He was taken to a valley, and God's spirit sat him down. The Lord talked to him about amazing things concerning future events and places he has never been before. He asked him a question that Ezekiel could not ignore, "Do you believe that these dry bones can live?" The word was alive will when God asked the question. Ezekiel didn't have to think at all. It was important that he answered the question correctly. He replied, "God, you know they can." But what he was really saying is "God, you know you will." Then the Lord said to him, "Command the bones to stand, and live." And this was exactly what Ezekiel did. Immediately, the ground was shaking. The valley of the bones started rattling. The earth began rumbling and moving around as Ezekiel watched in amazement the power of God performing a miracle. An army, fully erect and ready to serve the prophet. All were ready for battle because they were perfect, in fleshless form, and without any earthly fear or doubt. Ezekiel waited to hear the next command, which was to take the land. Then I heard the voice say, "Do you believe?" I responded, "Yes." Suddenly, I was there and here at the same time.

Vision of the Mountains of Israel

"Thou son of man, prophesy unto the mountains of Israel" (Ezek. 36:1, KJV). Listen to the "word of the Lord." I call you to come to me, says the Lord. The enemy hath spoken against you, but I have kept you by my mercy and grace, through every ancient and high place throughout time and every generation.

Suddenly, I saw the "Ancient of Days," the knowledge of time that governs all prophecies, and I saw an image of the creatures of old. I heard the voice of God call each creature by name. The Lord God commanded the ancient spirits to rise and fulfill their prophecy. The paintbrush continued to strike the canvas of heaven the revelation of the earthly spheres became known. I saw the image of a man in flames standing by the bush, but he was not burning. He was an earthly man called to fulfill his role in time. The voice said,

29

"Keep watching, you will see him clearly." I was moved into another realm instantly. There I saw a man named George W. Bush, he was the president at the time of the attack of September 11. How could this be? God replied, "Every person is numbered in the word of God. Every child comes into the world by a number and will fulfill that number until the last number is called. I watched the hand of God as He continued to paint events and people. As the images kept presenting themselves, I watched the glory change from silver to gold, circling the throne. I saw a beautiful wheel of gold just before I woke up in my bed.

The next day, I was stunned because everything around me seemed to radiate pure gold, including the grass, clouds, and even the people around me. That night, I was caught up into the presence of God again. The hand of God began to paint another image, America, I saw crystal waters pure and sweet, but with a lot of pain in the people. It was like rain pounding on them; yet they could not scream out for help. I watch their tears flowing down their cheeks. It was now time to see more; I wasn't sure my heart could stand it at all. I saw the apocalyptic revelation horses from the book of revelation released to go and suddenly it appeared on the canvas in front of me the picture came to life.

I saw in the book of Daniel it is written that two thousand and five evenings would pass and that all that was contained there concerning our future lay there. The raising of the image of time formed before me in a misty cloud and suddenly appeared on the canvas again; now it was in the shape of the nation "Iraq." The time was 2005. It was for war, a war that would never end. This was the time to begin calling out for God again. I saw the first image in the shape of a boot. Our president at the time came from "Texas" the shape of the cowboy boot. The image not only appeared on the canvas painted by the hand of God but also on the wall of heaven; then it vanished immediately before my eyes. Then another scene came on it. The mountains then began to call out into the air, "because, because," they shouted. "You have made us desolate and wallowed up your God. You sell your souls to behold what is unholy, and you have traded your beauty to the enemy. You have become a possession

unto the residue of the heathen, and you have become a friend to your captures." I saw kingdoms fall from the Middle-East to the East then the North, and across the oceans. I heard the mountains as they shook beneath the fee of the King of kings. As my hands lifted up towards the sky as high as they could go, I realized the passion of the Lord was hovering over all who did call upon His name.

Poetic Gems to the Isle of Peace

An island sitting in the middle of the sea, no doubt it is for me. I am here to find the peace of mind, which is mine. On my isle, there are beautiful flowers, green and red, very fresh. Today I must find myself. I will. In God, I trust.

Vision of the Bride

I sit in the throne room, the Holy of Holies. In my chair, bright and fair, I wait for the word that will make me rise and take my place beside my love, the King of glory whose name is Jesus. Some even call him the King of kings. His name, I will see one day. Many have come to stand before Him in times past who have all gone on, yet my love still remains. As I watch for Him with great anticipation, I desire to be with Him now. He is my beloved one, my Lord. I must stand before Him complete, without blame, and shameless. Only faithfulness can greet Him. All of the other earthly acts try to deceive me and even entice me. Foolish is man to think he has the power to persuade you. God. You cannot be bought or even sold. You own it all. Every hill and every valley has been paid in full.

Father, I rejected all worldly enticement because I only want you. I rejected them sharply. No one can take my love away from you Lord. My heart belongs to only you. I cannot be bought through deceit for worldly delights for I desire your bountiful hope everlasting. Night after night, I would go to this beautiful place in heaven, and my mouth would write.

Day Ten

On another particular night, I decided to go to bed early. I fell asleep in the chair. As, I closed my eyes, my physical body was transformed from the natural to the supernatural realm. The spiritual body became visible and invisible at the same time. It is hard to explain, but everything instantly changed. Mind, body, and spirit unified into one. Immediately, my mind and body bonded in a peaceful, serene state. I entered an open entrance into the greatness of God. Standing before me was a glass door, but not like a glass door on earth. I saw a golden pathway and stairs of gold and silver. I went inside a space of blue and red colors. Inside one door, there is a connecting door. It was the way of salvation. There I saw there are different elevations of salvation with many colors blending in beautiful, magnificent patterns.

As I approached the first door, it opened wide, making room for every soul entering at that moment. It was glorious, and brilliant with light. I saw people of all shapes and sizes, waiting patiently to enter the gates of excellence. Yes, "The Bride of Christ" was waiting for all humanity to join her in eternity. I felt great joy, but my heart became heavy because I knew many did not make it. *Could I have helped them?* I wondered. *Could I have showed them the way to this great event?* As the line continued to move without losing a beat, the lingering thoughts of yesterday vanished away. The lost remembrance of the past melted away, and the forever became visible, revealing the complete end. For the foundation of all things burned away in the thought of yesterday.

I did not want to leave this beautiful, most holy place of grace and mercy, yet deep inside my heart, I knew my life's end was not finished, only halted but for this moment. My face was covered with glittering gold and silver again. I was not afraid as I moved about in the heavens, instead, a fire burned inside of my spiritual presence with intense anticipation to see more. I knew this was a test for me to believe for God was trying to stretch my faith to do His work on Earth. Oh, how I loved Him and wanted to honor Him! I felt a

great presence to stay there forever, to dwell there and not go back to reality.

I heard the angels singing in perfect harmony and playing golden instruments. Nothing that was shallow or weak was allowed to linger there. It was a holy place of sweetness. It was perfect. The sound was for the generations the sound is what holds all things in place throughout time. With pure grace and mercy, the windows above my head opened up. Once again, the mist swirled around in the air and blew life, and light filling the empty spaces completely. I saw the crystal water so clear as a mirror reflecting all my tears. A sudden eruption of shouts and praise rang out, shattering the heavenly state as everything began to sing praise with voices so clear, voices of many waters and sounds of glass with comeliness covered the outer banks of air of heaven. Somehow, I understood everything that was happening. All of creation was worshipping the Master of time. The eternal creatures and angels were ushering the kingdom of heaven together in perfect harmony.

So great and fair, the Master of all things arose and hovered over my head, making me bow with humbleness and grace. I bowed before His throne. My heart cried, "Before Thee, I bow. With humbleness and grace, I give honor and praise to Thee." There will never be a season of pain, nothing to disturb my rest. Never again will I experience the sting of rejection or be unprotected. "I'm free! I'm free!" I yelled. I saw the writing of hope on the wall of compassion. I could breathe deeply without heaviness or weight upon my chest. I could move in and out and float up and down without pressure. What joy! I asked the voice of many waters to let me remember for just a moment why I felt so wonderful. I had to know. I needed to understand why humanity enjoyed the spirit of pain. Like melted lava, the burning of flesh filled my nostrils, but only for a moment. I realized right then that man loved to suffer because it gives them an excuse for complaining. If we can complain to our Creator, then we can try to persuade Him to let us enter His joy without shedding off the robe of suffering. Jesus took away every sting of pain at the cross of Calvary. I saw the golden cross standing in the distance. Upon it was the banner of victory. I shouted, "Glory to the King of kings!"

All of heaven rejoiced with me as well. I heard a rumbling in the distance and saw a cloud forming to my right and swirling around frantically. I realized at that moment that my understanding caused this manifestation. It was the enemy of the cross. He, the spirit of suffering, was angry and enraged. I had the revelation in my mouth, and in my heart sealed with glory. I fully understood the power of it all through love and eternal peace. I suddenly realized that pain has always fought against the spirit of compassion. Jesus was always moved by it. Wherever He went, He encountered suffering. His compassion healed the people. His love for them is what pulled at His heart. He bore our sorrow and carried our diseases. He did everything for us. We were the only reason for His coming to earth. "For God so loved the world, that he gave his only begotten Son" (Jn. 3:16).

I was dwelling in the shadow of the Most High and abiding with Him in heaven. As I looked through time and saw what I had left, it was apparently clear I understood my mind-set. As humans, we love pain because it gives us a reason to complain about our earthly conditions. Our earthly choices either bring gain or pain. Unfortunately, we usually choose pain. This gives us a reason to complain to God about the outcome, just as Satan did in the garden when he spoke to Eve about the tree of knowledge. Jesus came to erase all that for us with His death, burial, and resurrection. He finished our completeness. We are deceived into believing we can bargain with God about it and our destiny. I cried as I saw this matter unfold before my eyes. "Thank You, God," I cried. "I see that only time can erase all that fear. You bore our grief, carried them away, and burned them up in Your amazing and incredible love." I saw the glory, the beauty of hope, the power of love, and the *goel* (which means "redeemer or restorer"). God made a way for all of mankind to be restored to Him, even though we did not even know it. For the glory of the Lord has been revealed so all flesh can see it and believe in it together with Christ (Isa. 40:5).

At that moment, I knew the only way to see clearly is to believe fully in the eternal purpose of God for us. I pulled down strongholds by elevating us upward toward the heavenly throne. I wanted

to know more. As soon as I thought it, it was that revelation of complete love for me, He did what He had to do to untangle the web of deceit over me so that I might soar into His presence and dwell there. I was instantly positioned into battle for the journey ahead until the end. I understood that these images of natural and heavenly things are always parallel in time. I looked up and saw myself upside down. I realized that what we see is really the opposite of what is truly real because what is up or above is the true picture, and what is down where I dwell is only what is temporal and will die eventually. If I understood warfare in my earthly estate, it could never have power by keeping me earthly bound in the position of humility and grace. I could defeat my enemy, and he could never defeat me. In this position, living life would become effortless. I would always win in any battle because my head, which is God's head, is armed with faith. I began floating through a misty wall of smoke, and the spirits of doom were watching me. I asked why they were there. I heard his voice say, "So you will never be afraid of them again. This is keeping you as you live your life in the natural." The voices of hope began to speak in unity at once. In order to overcome the powers of fear and doubt and destroy heaviness, fear must always be put under your control. With God, I could surrender to peace and reject the spirit of fear and torment.

Put fear
Under your
Control

My foot stepped on the enemies of my soul. With the authority of God, I did step on the head of torment and doom. I watched the gospel, which was the color of red and purple, stream through time, carrying the waves of peace around me and raining on my heart. I was imbued with power and might to go on and on until I could return "home." Along with the gospel of peace, we could ride the horses of heaven accompanied by the heavenly host and overcome the world with victory. I saw God understanding, white and pure, floating in heaven. It was as if a knife was sharpening all human perception of the natural things of life in preparing for eternity. I saw the land of hope. The only way to have a revelation is to cast off all things that separate your perception of God and your revelation away from God's heart. Whatsoever things that are true, never change it. All of heaven agreed. The revelation will stand. "Whatsoever things

are lovely, whatsoever things are of good report…Think on these things," Philippians 4.8 (KJV) says. When God speaks, it is always the truth. When we look at evil, it is always opposite to the truth of God's word. Therefore, whatever is lovely and of good report, we should always think that the devil is the very ugliness of evil, therefore everything that is evil comes from darkness.

In an instant, darkness covered the deep. I asked God to let me see His glory and to never let it leave me. The smell of glory so sweet, like a rich fruit in an orchard. It was awesome! It was overflowing with rivers of joy. I looked down at the gate, and I could not stay in that bent posture. I was now in the narrow pathway toward even greater glory. I understood that now I was called to be a carrier of His most holy love. I was no longer rejected and wrapped up in lies and deceit. No longer could the snake of lies coil me in disbelief. I could give pure glory to those He would send me too. The revelation about who I was meant to be had freed my mind and soul to see how great the Almighty is. I am privileged to be entrusted with His authority, which gives us all a sphere of influence. I understood what the word *down* truly meant. I did not have to live there, and neither those that were broken too. I asked, "Will they listen?" He answered, "Go and see." I looked through time and saw positive responses. So I opened my mouth, and He filled it with gold oil. Everyone of earth from the dawn of time man has searched for the gold, believing that it could bring them hope and serenity divine. It shall, it will, and it can calm their fears as well of tomorrow's trouble, pain, and woes, drying up all their tears. I saw the wagon wheel of time, turning over and over. Those brave pilgrims searched high and low, panning for gold but finding only a little. Most died before they found any and are heartbroken forever. Then I saw the image of thousands of souls through the lens of the Lord, watching them search and becoming disillusion over time. Today we are seeing that yesterday searchers were really overcome by the lies of that old beast, the great deceiver. Nothing can buy our happiness because we were created for eternal rule. As those weary hearts cried, they had somewhat forgot that their rewards lay in the "city of God," where gold is laid up for them to walk on. They indeed were willing to search for God and His righteousness.

I saw that earthly gold can only shine, but cannot do anything more than that. I heard the angels say, "This way there is more for you to see. For here is where it is pure and can never ever be erased. This is where it begins, and this where it will never end. Behold gold is in your mouth." He said, "Yes, pouring out like a waterfall. The golden words you will speak will melt into the hearts that cry, and all will be filled with that same gold inside. Go!" I saw the words run like gazelles, leaping and dancing and chasing the people down.

The place where I stood at that moment was filled with total security and divine love. Nothing could separate me from God and His glorious presence. A gentle cool wind blew gently across my face, and a new season manifested right before my eyes. I heard songs about those who are lonely and broken, waiting for someone to visit them. The voice suddenly changed from singing to a widow crying for companionship. "Here I am, sitting all alone, staring out the window, and watching the world go by. Who will care for me?" I heard her sighed. "Oh the seasons, how beautiful they are, with the red, blue, yellow, and gold flowers. How beautiful the seasons are as time changes." Suddenly, I hear her say whispering ever so softly. "I am not the same, I guess. Just as the world goes around, everything must shift, making room for something else more important than me." I do not want to be as I was yesterday because I can see the mistakes I made. She continued to cry, "Oh Lord, if it means that I must keep moving, please! Hold me close until your return. At which time, I will close the chapters of my life and behold thy glorious guiding light." As I was listening through time, my heart was crying. "He cares, He hears, and He will keep you! You will come to this place one day soon, it shall be over. God is your husband!" I whispered back.

Through time and space, I know she heard the words of hope switch on the light eternal. While in this glorious place in time, I prayed for not only her, but for all the people who were just like her. I watched the light switch from that scene to another. A wounded soldier was carried by another soldier on the battlefield and the words "Coming Home" rang out like Christmas chimes throughout centuries. Poetic words again filled my being. I heard the King of kings

say, "I know them all each by name. I sing over their hearts of pain." Then I heard the voices singing softly for them again. The voices of the angelic host echoed the words "Wars and rumors of wars, both natural and supernatural, here is one of those soldiers. Christ is His name." There is a weary soldier, I do not know his name, but I could see his pain, his suffering. He longs to have his life the way it should be. He is locked in a shield of misery. The angel of God carrying his sword of hope as the soldier bled and cried. The other soldiers refused to leave his side. I saw a picture behind his head, and it read "Misery." The angel prevented me from trying to help them. I had to watch and listen to their voices that blended as one voice.

Where is my purpose? Moreover, where is my hope? I see the image of grace; so I know I'm on the right road. I saw another wind as it moved towards me. It covered my face yet I could see clearly by this heavenly faith. I saw in the distance the image of Jesus walking up that awesome hill a sacrifice for all of us. He bled and died for us, but through His miraculous and glorified power, He justified us thus gifting us with grace. How could we resist such a marvelous gift of eternal life with "Him." I saw the glory lighting the air.

As I suddenly looked down at my feet, I saw the jewels of hope glistening like diamonds, and the streets are lined with gold and diamonds. "What a beautiful place heaven is, a place waiting for us to dwell throughout all of eternity.| My heart rejoiced with admiration and joyful hope. With stammering lips, I blurted out, "Praise to you, oh God! The great God, Jehovah" The reflection brought hope eternal, never to die again.

He was the first real soldier to die on that lonely hill so long ago. All my heart could do was worship and adore Him for all He endured. I was carried by the wind and sat on a hill. Looking down, I saw the colors of purple, black, and red. I said, "What is this I see?" Without a doubt, I knew it was bruised and battered for me. Suddenly, more ancient words appeared before my eyes. No fight is without pain and suffering to bring forth the most precious gift. I

understood what God was trying to show me. Never surrender to the will to stay free from pain. It is in that pain that we find the will to give life. The pain of mothers caring for their children who were all battered and bruised and, yes, even used for filthy gain. I saw a beautiful woman at the altar waiting to be loved. Then the wind blew briskly again and changed the entire moment.

The Wealth of Wisdom or Silver Threads Poetic Gem

Woman of time, wisdom divine. I have been around for many years. I have cried throughout the night for my children and my grandchildren. They are my silver pride. I have turned white on top of my head. I have listened to their laughter in my lap As I held them until the morning light, I have learned how to be a woman of royalty by being redeemed through my loyalty to them, God has given His best. Now I can rest.

The Breaking of the Vows Poetic Gem

For this cause, I leave my mother and father to cleave unto a husband. I stand at the altar, getting married to a man. I ask, "Will He love me? Alternatively, will he leave me?" The woman cried. She knew the answer before she asked it. Somehow she knew the answer. Still she asked, "Will I be battered? God, let me see the mothers who were trying to raise their children alone. Daddy's gone and left the home. Children were left broken, and so I cried. The forgotten rule to keep God as number one, He is the only way to be strong. Without him,

all is done. I saw a river of women, slowly walking through a sea of many streams, holding children close to their hearts as the tears trickled down their cheeks. I asked, "What will be their hope? The voice echoed loudly, "Love. What is true love? Where is love?" The voice of hope answered, unconditional surrender, always at all times. It is as wine that heals from pain. I wanted to know more so I called out to Him, "Please show me more." And he did. "Oh, how beautiful you are, world of God!" The voice thundered and sweetly spoke. "How is this possible?" "You are thunder yet you are soft and sweet? Please teach me," I cried, "for I want to understand." With His tender hand, He reached for me, lifting me up again into an even greater state of glory. Each time I went up, it was more elevating and glorious, even higher than where the eagles fly. The voices of grace and mercy began to sing. I heard the praises of all say, "He is God, He is God!" I looked down at my body and saw the words moving inside of my heart. Making the actual colors of all humanity, living and breathing inside of my soul, so I began to sing along with all of heaven. "In the beginning, God was and has always been," I heard my voice agree to this. The words were writing themselves throughout my being. I heard His voice say, "I call to the firmaments below. Let there be light, and it came to be." He separated the light from the dark. This is God! Then the voice beckoned all the trees and animals to come. Can you see? Yes, I did because I believed. The voice asked, "Can you agree? I have given you hope. Do you agree?" Yes, I see, and I agree. "Now I will make man in my image."

At that moment, I knew it was God. Was I losing my mind? The voice spoke and said, "You have found your mind." This experience seemed to go on

*for days and days, but I knew it was only for some
hours. I did not want to leave this place of glory, it
was too special.*

"Why couldn't I have stayed?" When I asked God, His answer
was, "You have to work while it is day." His voice spoke to my heart
in a tender way. The next day, I was confronted with the dream. I
grabbed the first person I met and bear-hugged them without even
asking if I could. Miraculously, they let me and received me with
love.

Poetic Gem Young and Tender

I saw a girl on a beach. The hand of God painted another vision
again as I heard Him whisper in my ear, "Can someone hear me?"
I realized it was the image on the canvas. "I am here all alone, only
the sand around me to be my home," she said. "The world is sur-
rounding me with teasing thoughts as I am stuck in my own space."
There she was, the beautiful girl waiting to be uncovered from the
fears of her world with its cruel and taunting words. I could hear her
thoughts and as I drew near I could hear her heart beat.

Poetic Gem Can You Hope Again?
Can You Believe in Me?

Can you believe? Believing was something I was learning. As a
child, I desired the fantasies of my childish dreams. Little did I know
that as you grew, I would need more for the world is very cruel? As we
grow, we hurt more too. No one told me about his but I found out;
it is true. Growing sometimes makes us blue, "Can't you see, I am
you!" But, I do not sing that song because Christ came along, and I
gave my heart to Him. He took my heart and blessed it, and filled it
up. Now there are no empty places in my cup.

Poetic Gem I Call Out

My arms are open and waiting for you. I know it won't be long. The hours are ticking on the invisible clock. It will soon turn for you are my light and dreams for tomorrows. This is the final twist. I am moving toward the end of the eternal age. "May I walk with you? You look like you need a friend the" voice said. I remembered at that moment the time when I was at the end of my rope. I didn't quite understand why I felt there was not any hope. It seemed the more I tried not to feel the pain of the world I could not shake it. I just could not see my way clear, so I decided to walk, and really think a while. To my surprise, I heard a voice speaking out loud. "Where are you going? I would like to go with you." I was not sure what to do, so I turned my head slightly to see if anyone was there. I heard the voice speak again and say, "Do not fear, I am here to walk alongside you. Where I am, fear cannot stay. I will give you exactly what you need, and that is love." There is the fountain that flows with joy. People get healed when they drink from it. I took a drink and I could instantly think clearer that I had ever done before. That day my life changed.

Poetic Gem I Need You Paradise

Twice you came and left again. I have searched the whole world trying to find you. Now here you are, so near but seem so far. Let us never depart my paradise, my love.

Poetic Gem (White Flower). I lay back. You are beautiful. Yes, you know. There is no chance of confusion for the only color is not right or wrong.

I feel myself cooking. The fire is burning and churning. Yes, I am learning. He is making me into gold. I cried, "Oh Lord, please no more!" Bu, what I hear is "Do not fear. You will not be consumed for I am with you always and will never leave you on your own." This, I say, "Please, how much more?" I hear you softly speaking in my ear so sweetly. "Your life is a sacrifice that will burn down every door that separates you from me. It will hurt some, but let me cook

you more. For you will arise from this cry and never die anymore because I will come real soon. You will be well done, and you will hear me say, 'Come Home.'" The only way to see through the eyes of God is by loving unconditionally. Cain killed his brother and tried to get away from the cooking hand of God. His brother's blood cried from the grave up into the ears of God. God asked Cain, "Where is your brother?" His answer was, "Am I my brother's keeper?" God responded, "Your brother's blood cries from the grave." For this act of violence, the Lord marked him in his forehead, marking it for all of remembrance throughout his life. It was something he could never erase. Therefore, let God cook you, so to speak. Only love will remain, and heaven will be your gain.

Poetic Gem Destiny Foundations Shake

My teaching was nearing an end, I heard these words in a poetic flow, "The dirt flakes the ant builds, the bee buzzes, the feet walk, the people talk, the eagle stalks, The sheep follows. The shepherd leads, and the king speaks. The earth moves as the wagon wheels grind away, pulling the load of the day." Someone cries, "Hey, this way!" But there is no one listening, only the hollow darkness. Oh, there is some hope, now I can cope. But soon it slips away, and the search for destiny I still seek. I searched for my destiny, even though I did not really know what to search for. I just knew I wanted to do something good. David, a young man tending sheep, was busy following his father's orders. Destiny came knocking on the door one day. He was summoned into the house after all of his brothers came first. Thank God for the true prophet. David truly committed to doing a good job by keeping the sheep so God knew that he would most certainly do a good job ruling the people of God. Samuel the prophet looked at all the sons, but God chose David, the youngest son of them all. All the other older sons were disqualified for the job. As David entered the room, glory filled the house, it was clear that he was the one so he was anointed for kingship. Yes, he would rule Israel and defeat the giant Goliath.

Poetic Gems

I heard the moth when it flew into the wall. I just knew he was dead. But I turned toward him just in time to see him defy his outcome and certainly his fate. After all, moths aren't supposed to live longer than a day anyway! "Why fight? Why not just give in!" I shouted. "After all, at least you know it's over." It made sense to me. Thank God he didn't listen to me. Maybe I was to learn something about mistakes in life. I watched him intensely wrestle with death. I wondered, *Why fight?* Though it may have been a mistake or on purpose, he was determined to show me living life to the fullest. That is how humanity survives and continues to claim victory. I tried to help him, but he did not want help. He had a message for me to learn, never give up. He manage to stabilize his mishap. He did it, regaining his balance and again took flight into the night, leaving me with a sense of wellness within my soul. For that, thank you.

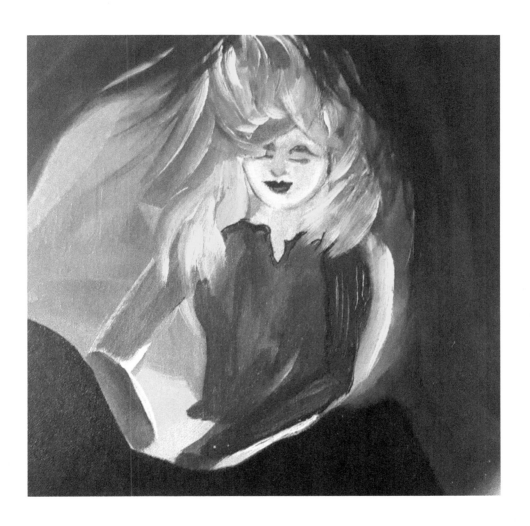

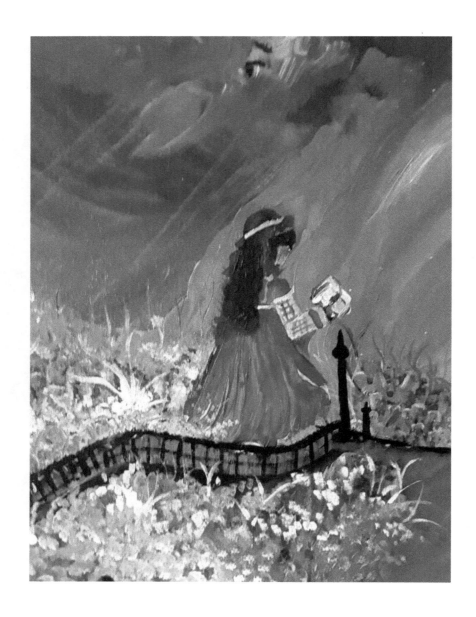

I SAW THE GLORY

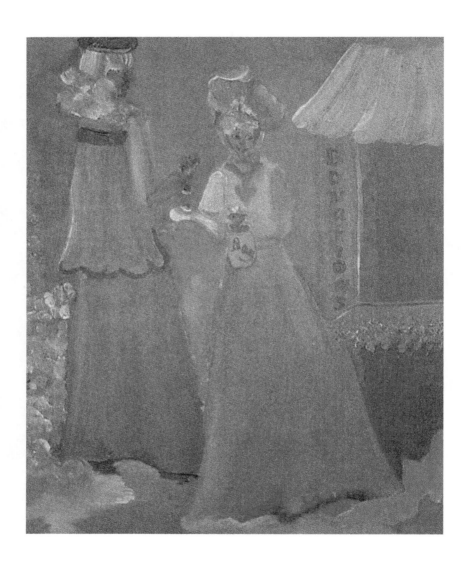

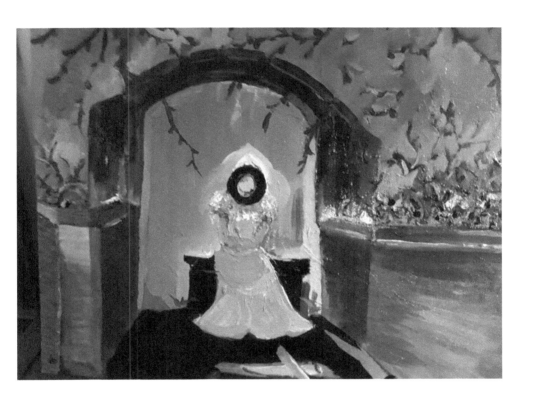

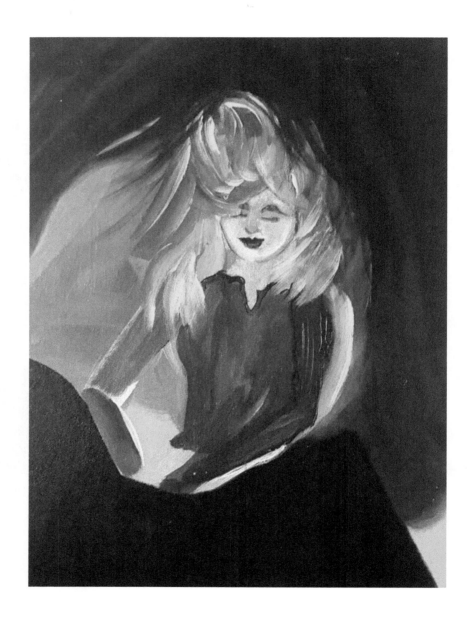

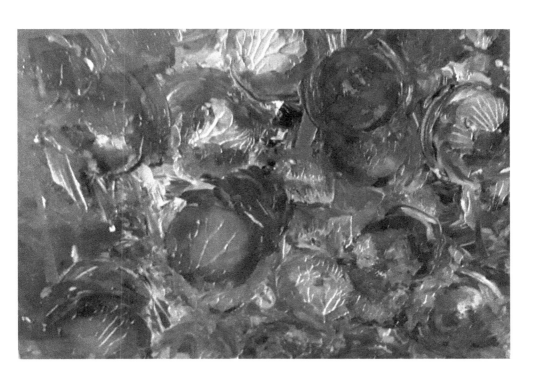

DR. DURUSSIA JENKINS

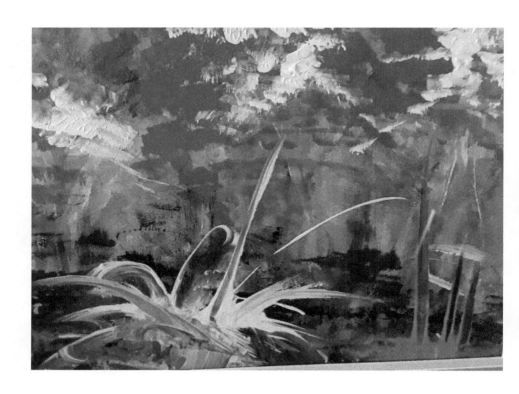

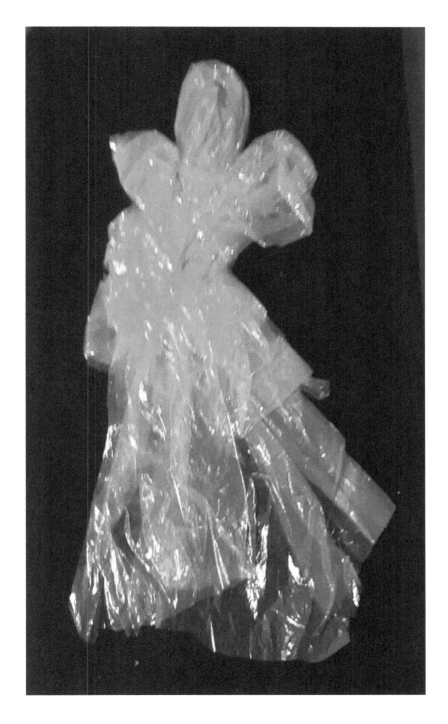

DR. DURUSSIA JENKINS

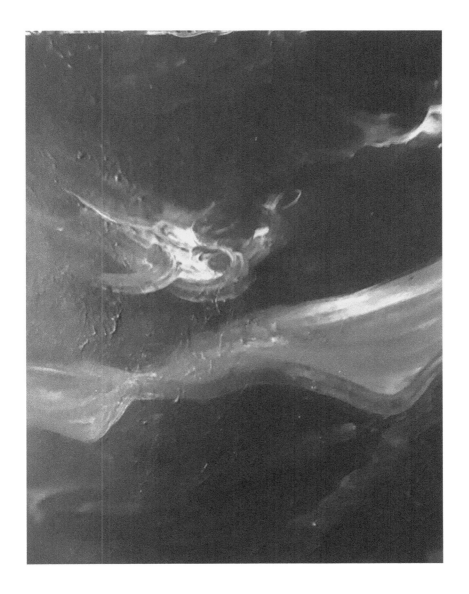

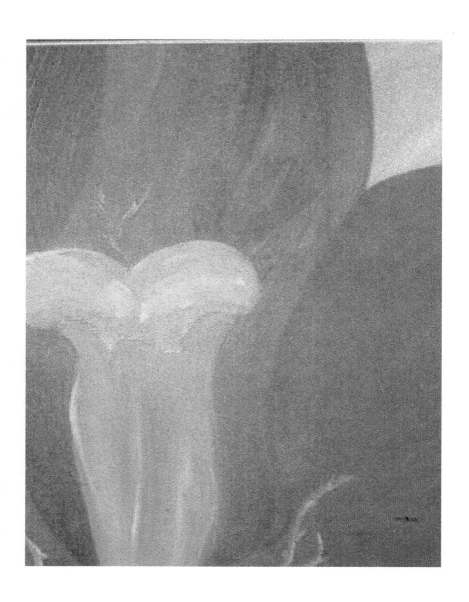

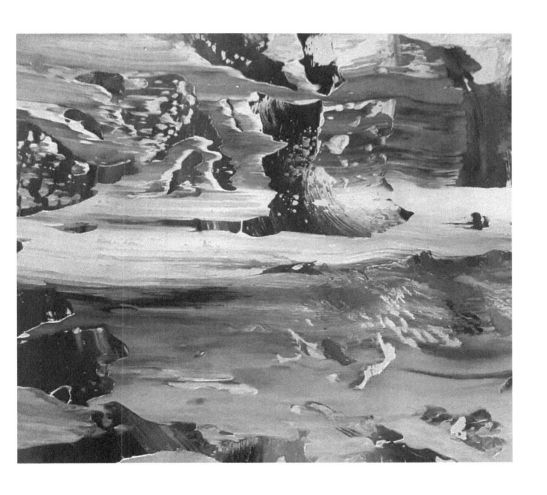

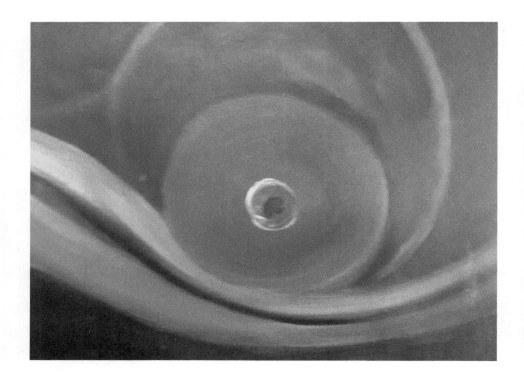

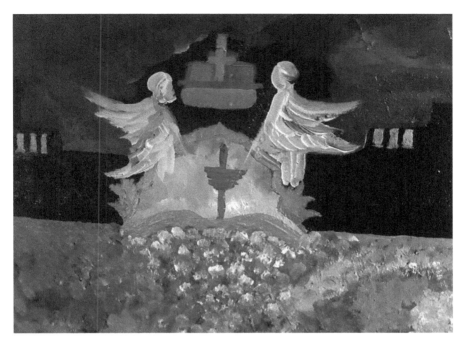

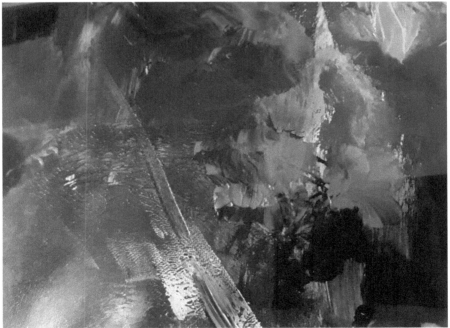

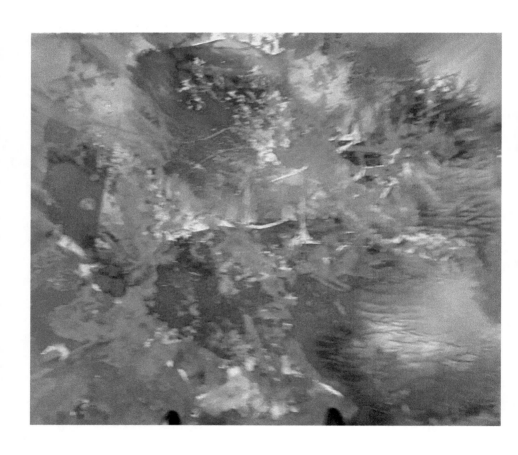

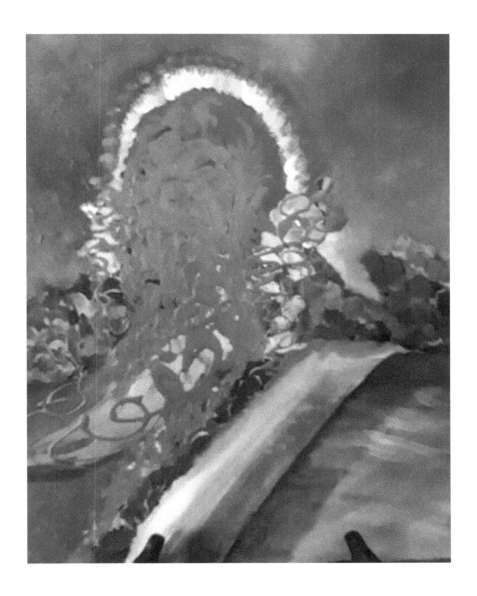

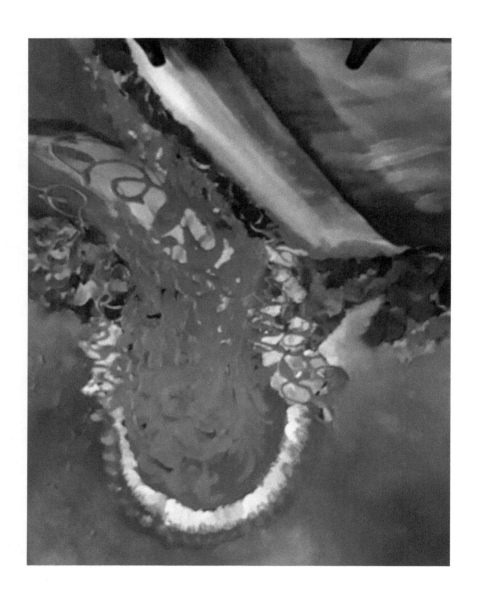

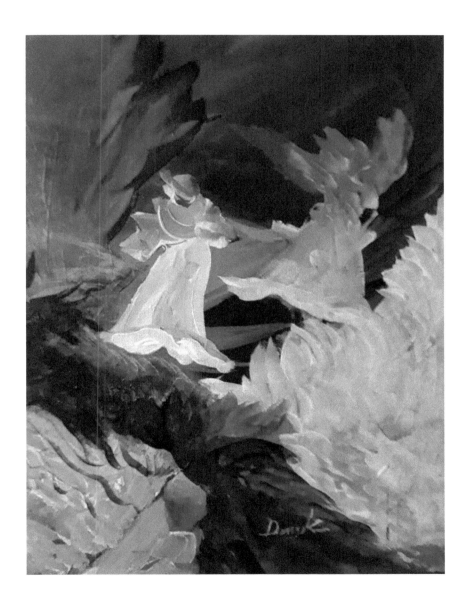

I SAW THE GLORY

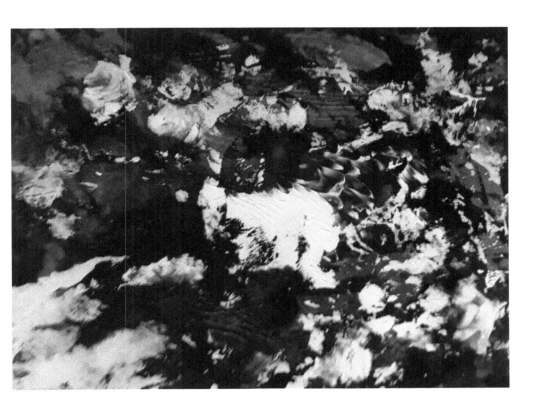

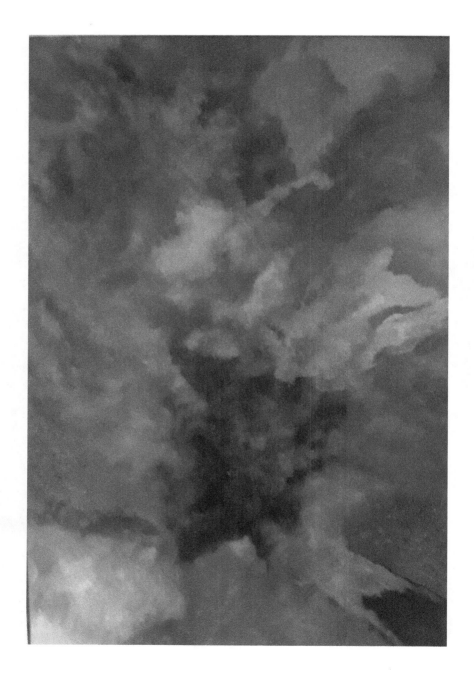

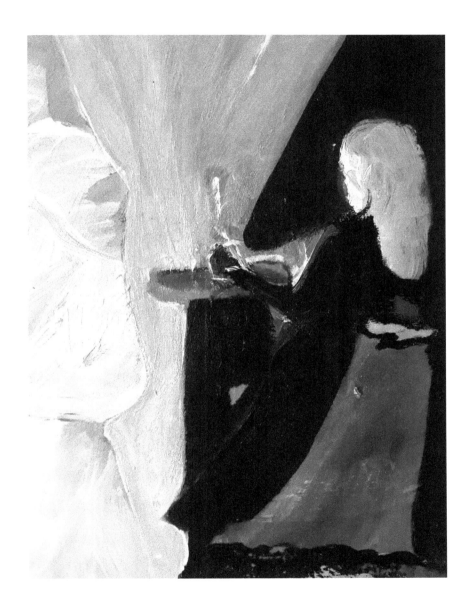

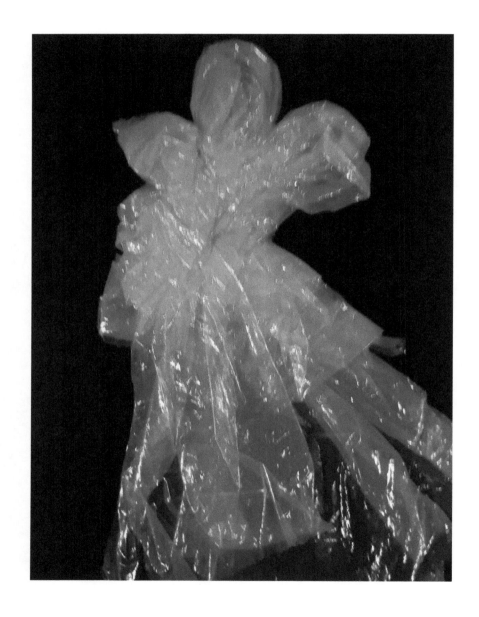

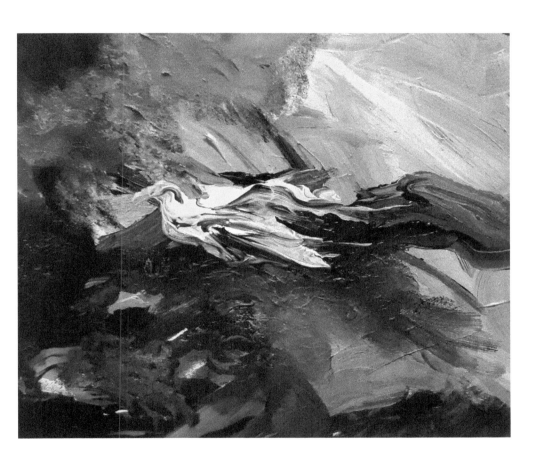

I SAW THE GLORY

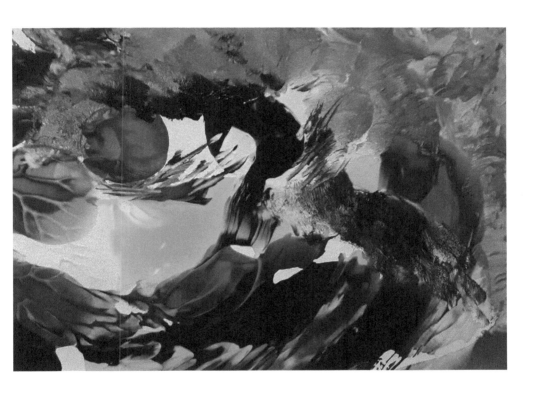

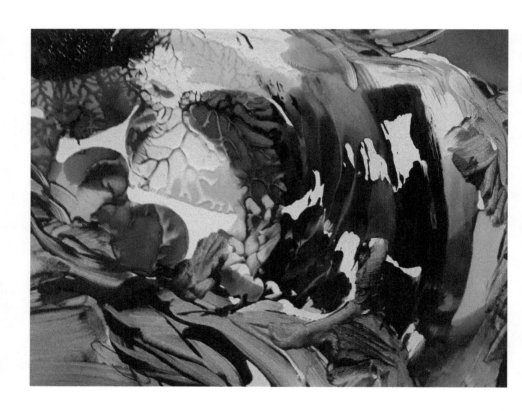

About the Author

DR. DURUSSIA JENKINS, WHO HAS a doctorate of Christian theology, has been writing all her life. From early childhood, her passion was for writing and telling stories orally. Her first work was a children's book she cowrote entitled, *I Was Fine till the Crab Moved In*. As a minister of the gospel and a public speaker, she would captivate her audience though truth and wit.

Dr. Durussia is also an accomplished artist, having painted over two hundred works of art. She is a nurse by trade. Through the sales of her artwork, she has donated thousands of dollars to help with the building a medical center in Kenya, Africa, and an orphanage in Mexico.

As a United States Air Force veteran, Dr. Jenkins wanted to give back to the military by managing a United Service Organization (USO) group called Danee for three years. They traveled across the States, from base to base, bringing joy and hope to the troops. In 2011, Dr. Jenkins was honored in Nashville by the gospel music channel as the Woman of Substance at the BMI Awards for her work in missions around the world.

Durussia's life has exuded faith, hope, and a lot of mystery.